NEW WORK

AT THE ISABELLA STEWART GARDNER MUSEUM

This book is published in conjunction with the exhibition:
Laura Owens
May 31–September 16, 2001, at the
Isabella Stewart Gardner Museum, Boston.

cover © Laura Owens.
Cover photograph by Douglas M. Parker Studio, Los Angeles.

Endpapers show details of a Furnishing fabric,
French or Italian, 1725–50. Silk tabby embroidered with
silk yarns, chiefly in long and short stitches, 22 x 86 inches.
Photograph courtesy of the Isabella Stewart Gardner Museum.

Design *by* Laura Owens and Gail Swanlund.
Typefaces Requiem and Knockout *by* Jonathan Hoefler,
Hoefler Type Foundry.

ISBN 88-8158-328-3

Printed in Italy

Edizioni Charta
Via della Moscova, 27
20121 Milano
ph +39-026598098/026598200
fax +39-026598577
e-mail: edcharta@tin.it
www.chartaartbooks.it

Isabella Stewart Gardner Museum
2 Palace Road
Boston, Massachusetts 02115
www.gardnermuseum.org

Artistic programming is made possible *by* the Barbara Lee Program Fund,
The Ford Foundation, the Wallace-Reader's Digest Funds, and
the National Endowment for the Arts. Major support for this work
this year has been received from The Boston Foundation.

In addition, a portion of the Museum's general operating funds for this
fiscal year has been provided *by* the Massachusetts Cultural Council, a state
agency that receives support from the National Endowment for the Arts.

Laura Owens is represented *by* Gavin Brown's enterprise, New York.

Table of Contents

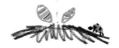

For A MONTH during the spring of 2000, the painter Laura Owens was artist-in-residence at the Isabella Stewart Gardner Museum. She lived in the old carriage house behind the Museum, set among the gardens and greenhouses. During her stay, she wandered the galleries, pored over textiles in storage with the help of our textile conservators, sketched, painted, and bicycled around Boston. By her own account, her time at the Museum nourished her creative spirit by affording time for contemplation and work.

6

Laura Owens's residency was part of the Isabella Stewart Gardner Museum's artist-in-residence program, which since 1992 has invited artists to live at the Museum, where they use the collection and its setting for inspiration and reflection. There is usually a public component to each residency. Some artists present exhibitions of their work inspired by their stay at the Museum. Others present public lectures or give workshops to children from neighborhood schools. These artists bring to urban youth the power of the creative process, and envelop students in their passions.

A decade ago the Gardner Museum embarked on a journey to restore its building and galleries, and to conserve major works of art, in order to return the Museum to its appearance during Isabella Stewart Gardner's lifetime. We also committed ourselves to restoring the intellectual and artistic life that had been the essence of Fenway Court—the name Mrs. Gardner gave her museum. How strange it must have seemed in 1903 to see in the Fenway district of Boston an evocation of a Venetian Renaissance palace. Filled by its founder with objects from many cultures, Fenway Court was intended to be more than a museum. Rather, Isabella Stewart Gardner wished it to be a place where creative ideas would be nurtured and shared. As she supported and presented artists, writers, musicians, composers, and choreographers, the Museum did become a significant center for scholarly and artistic exploration. She befriended and championed Henry James, James McNeill Whistler, John Singer Sargent, and Ruth St. Denis—just a few of the many artists who in her day ranged from the mainstream to the cutting edge.

Today the Museum attempts to build on the visionary legacy of our founder by supporting the work of the creative artist and presenting that work to the public.

ANNE HAWLEY
Director

7

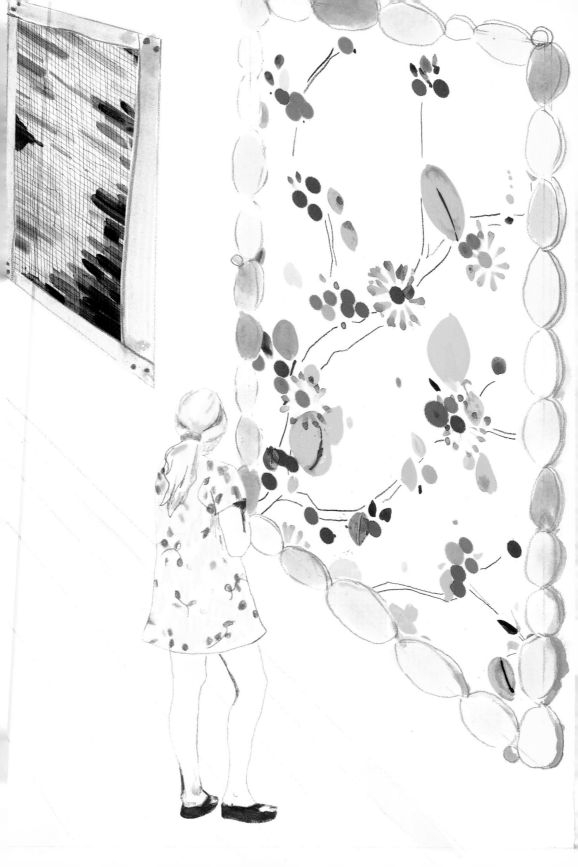

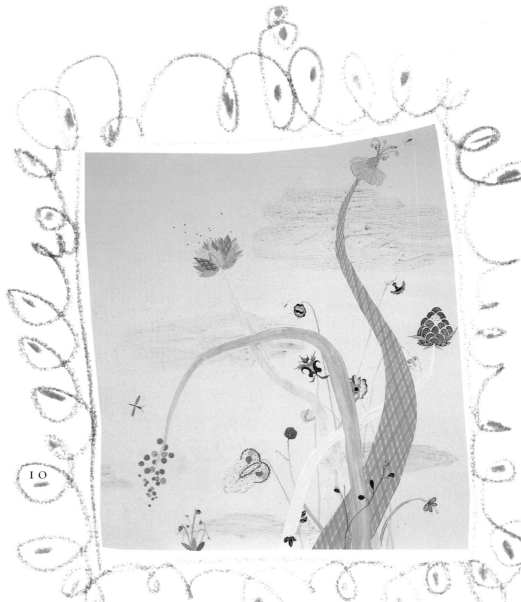

ACKNOWLEDGMENTS

For ALL of us who participated in some part of the residency of Laura Owens and in the making of this exhibition and artist book, the process has been an inspiring one. There are many people who need to be thanked for bringing this exhibition and publication to life. Artist-in-residence Laura Owens has brought to the Museum

inspiration for her art and work and has given us a wonderful exhibition and book to remember. The commitment, enthusiasm, expertise, time, and talent of Kathy Francis, Bonnie Halvorson, Richard Lingner, Dina Moakley, Kristin Parker, and the many staff members from curatorial, conservation, development, director's office, horticulture, marketing, operations, and security have guaranteed the success of the residency. A special thanks to Chris Aldrich, for his careful installation, and to Tiffany York, the program coordinator, who ably stepped in and successfully managed all aspects of Laura Owens's residency during the interim period between Jennifer Gross's departure and my arrival. Jennifer Gross, former curator at the Museum, first invited Owens to become artist-in-residence. She and Russell Ferguson provided us with two insightful and informative essays to the book, which were edited by Lory Frankel. Former artist-in-residence Ambreen Butt, who teaches at the School of the Museum of Fine Arts, Boston, gave us valuable assistance in arranging studio space for Laura to work in. The contribution of Gavin Brown's enterprise, especially Kirsty Bell, was indispensable to the exhibition arrangements and the book design. Claudio Guenzani in Milan and Sadie Coles in London were also very helpful. Laura Owens worked intensely and harmoniously with the California designer Gail Swanlund to produce this publication. Special thanks to Giuseppe Liverani of Charta for recognizing the merits of this project. Significant support came from the Museum's Trustee Program Committee, chaired by Charles O. Wood III, whose members include Sheryl Foti-Straus, Frieda Garcia, Lindsey Kiang, William J. Poorvu, Robert A. Radloff, Marcia Radosevich, David W. Scudder, Arthur I. Segel, Jeanne Stanton, Stewart H. Steffey, Jr., and Steven C. Walske.

11

PIERANNA CAVALCHINI
Visiting Curator of Contemporary Art

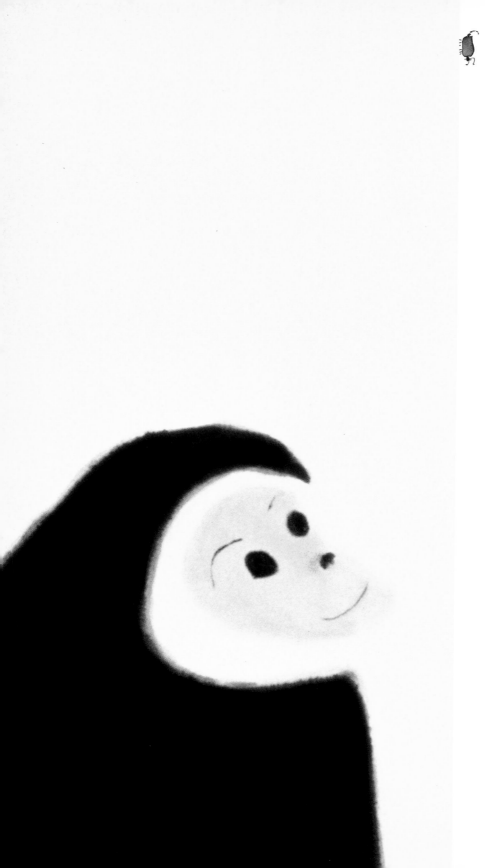

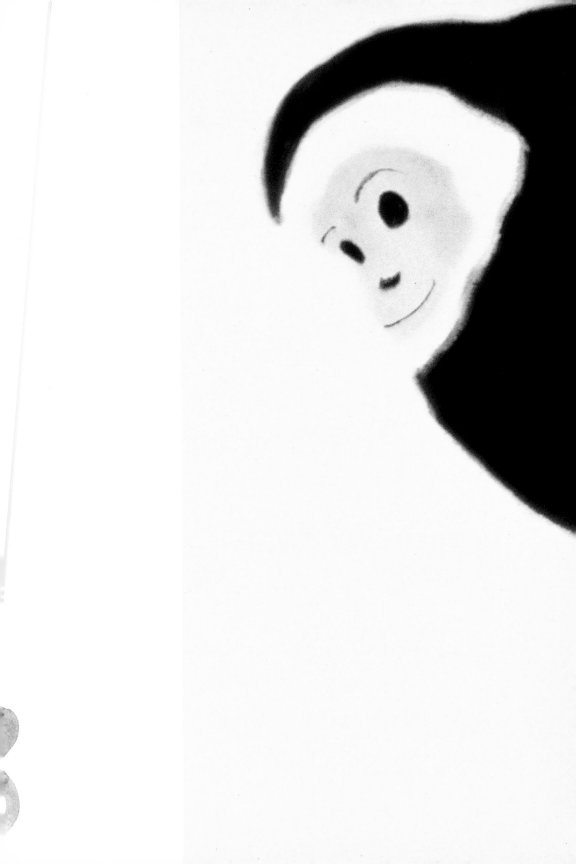

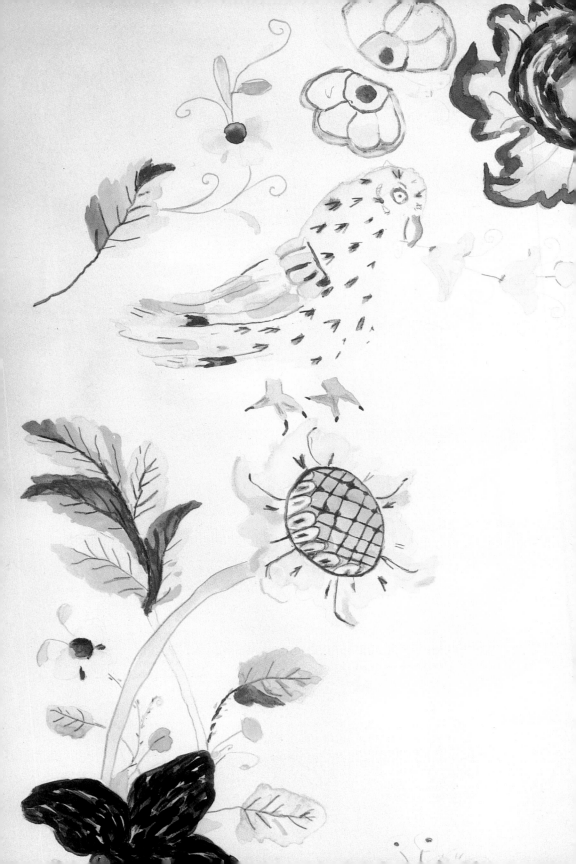

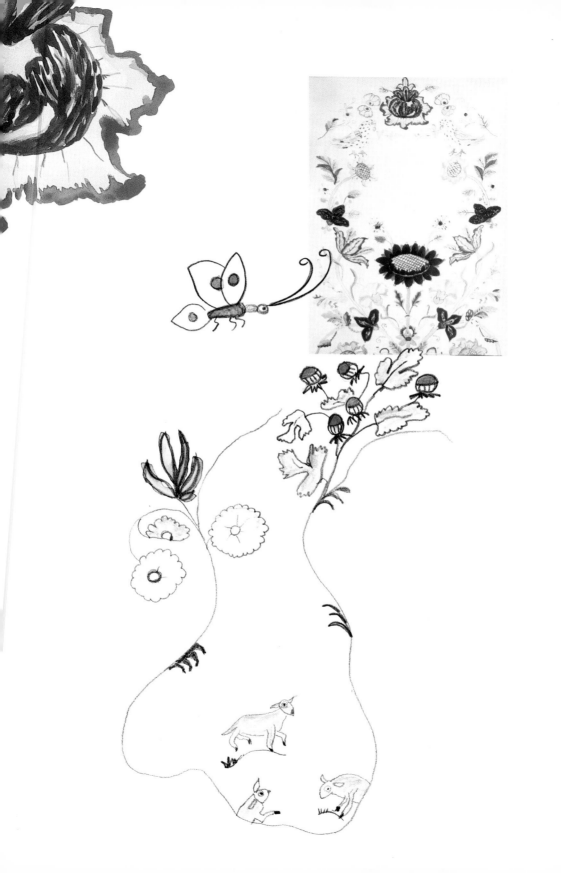

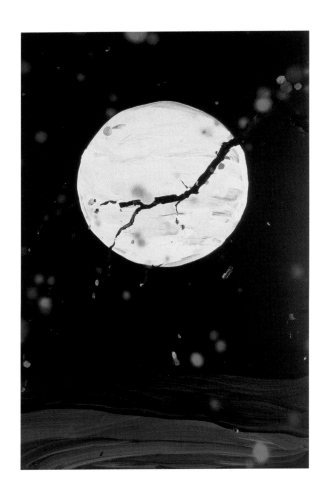

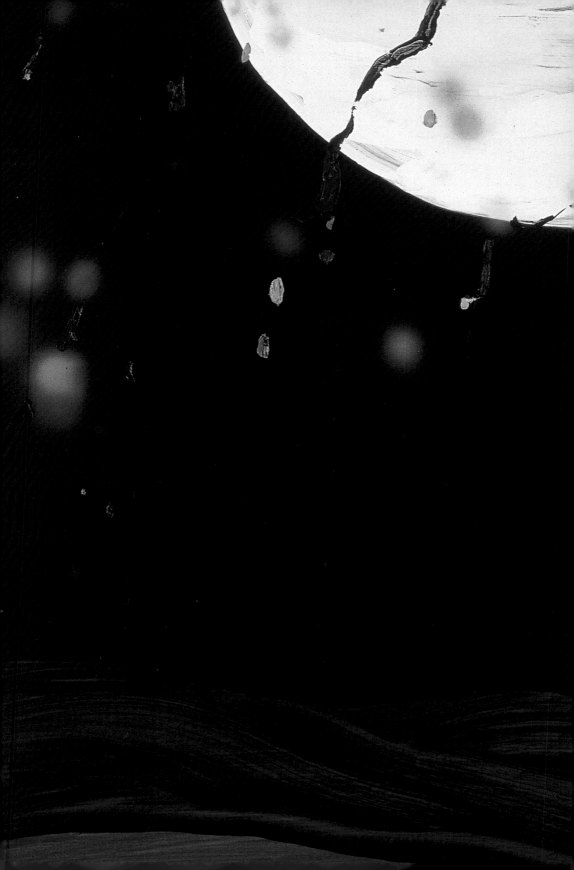

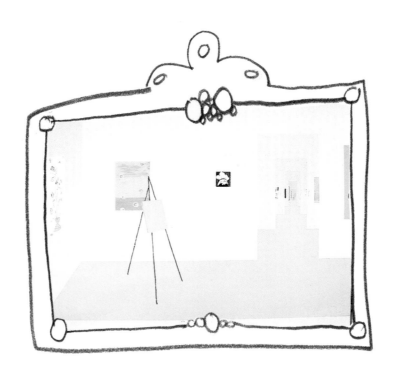

ARCHETYPE

JENNIFER R. GROSS

A PAINTING made by Laura Owens in 1997 presents an image of a series of white-walled, beige-floored contemporary galleries flanking a receding corridor. In the first room a blank canvas stands poised on a willowy easel, its raw, unpainted surface markedly distinct from the layered and highly finished telescoping shapes that form the floor and walls of the receding corridor. On the wall of this room, and those of the subsequent galleries, hangs a series of diminished paintings, small in scale and engulfed in the nothingness of the

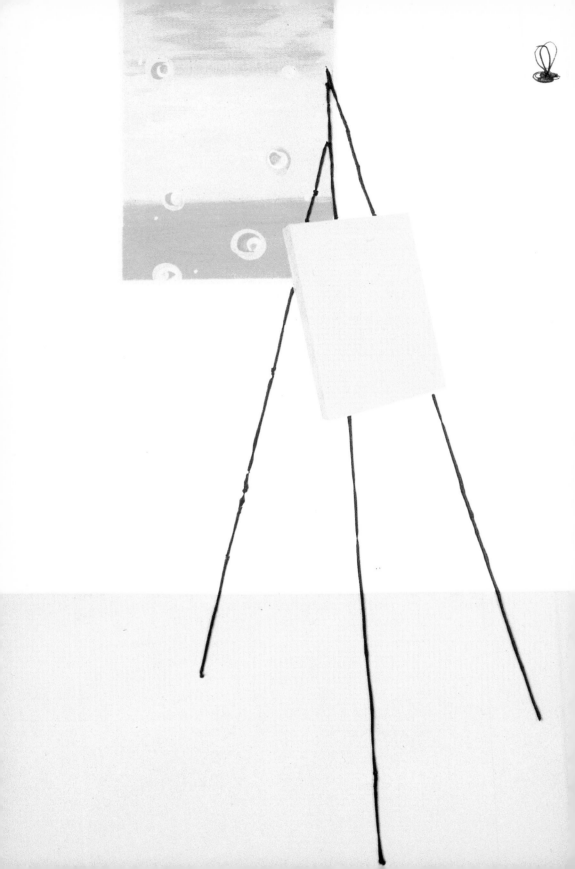

surrounding white, which slowly turns to blue down the passageway. This succession of white planes yields the images only an indefinite surface on which to hang, rather than offering a space to inhabit, a place to be paintings within a painting. The images look as though they could be depictions of Owens's own work, samples of the genres and techniques she often uses to make her paintings: floral still lifes, landscapes, abstractions, images stained and drawn on canvas. The scene brings to mind mirrored fun-house passages that reflect and multiply vision into infinity and challenge one's perception of place and boundary.

The image is large, 120 by 96 inches, so its scale draws the viewer toward the work; it implicates him or her as a participant in the world of museums and galleries as cultural pilgrimage sites. Its painting arcade offers an extensive, albeit peaked, cultural odyssey, at the end of which lies a metal fire door left slightly ajar, through which one can glimpse a crack of white light, a way out of the painting. The image is a cool and not too convincing representation of a place or of objects one might know, and it has just enough resemblance to painting to convey its relationship to the history of images as conceptual rather than mimetic. It references an all too familiar world but

21

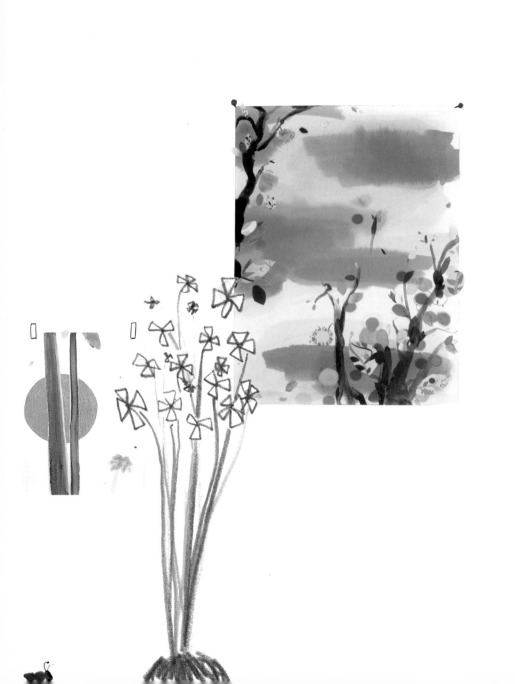

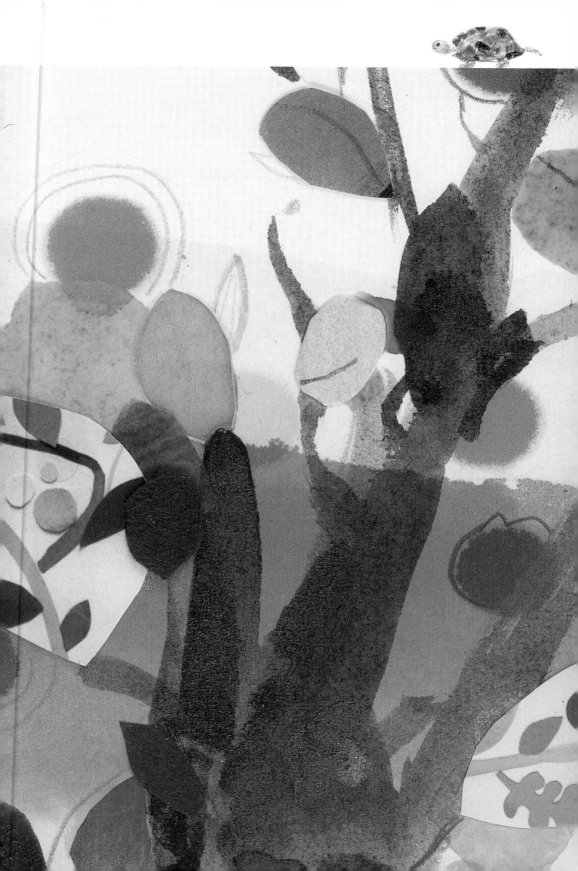

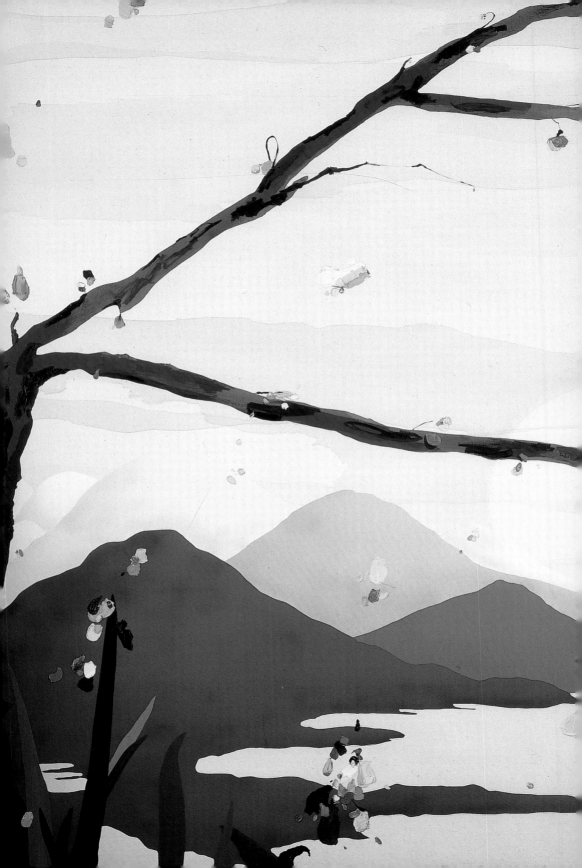

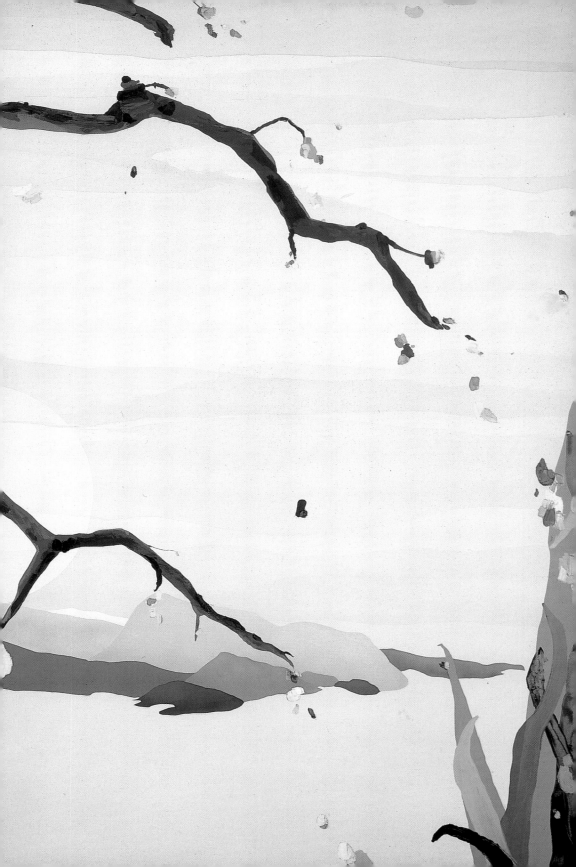

confounds the viewer's desire to know or identify its paintings,
or the work itself as a painting through representation. This
image deprives the viewer of what he or she has come to expect
of large-scale painting—color, emotion, gesture, space, brava-
do. Tired, distant, vulnerable, it is really more an assembly of
flat painted forms and arch lines on canvas than a painting, the
kind of demurring, user-friendly art that Owens has stated she
likes having around. As she puts it, she makes the kind of paint-
ing she wants to be with rather than "one that is constantly
telling you everything it knows. Who wants to be with some-
thing, or someone, like that?"[1]

The arcade of cultural revelation intrinsic to the architec-
tural plan of the Isabella Stewart Gardner Museum, similar to
the one laid out in Owens's painting, also sets the visitor on a
carefully calculated course of discovery when it is traversed
according to Isabella Gardner's original design. The Museum's
forbidding exterior was once entered through a heavy door
that opened into a cool, dark corridor. This passage led to a

1 Laura Owens, quoted
in Susan Morgan, "A
Thousand Words: Laura
Owens Talks about Her
New Work," *Artforum*,
summer 1999, 131.

THE ISABELLA STEWART GARDNER MUSEUM
above, The second-century Roman mosaic amid
the many stone works of the courtyard.

FACING PAGE:
left, The Long Gallery.
right, Spanish Cloister.

Photographs of the Isabella Stewart Gardner Museum by David Bohl.

bright light that was followed by a humid blast of sultry astonishment, as it widened to frame the lushly planted Mediterranean courtyard that was the physical and sensual core of Fenway Court. Once this chamber of light and beauty had been absorbed, the visitor would then begin his or her ascent through the succession of dimly lit rooms, displayed as cultural capsules, that line the perimeter of the courtyard on each floor of the museum. These galleries were laid out as a ritualistic procession of various cultures—Spanish, Asian, Italian, Dutch— in order to measure and present an unrelenting series of revelatory reliquaries of civilization. Isabella Gardner's international romp toward enlightenment included everything but a spontaneous aesthetic experience for the visitor, and in this Gardner could be accused of being a modernist, constructing an aesthetic form that was artificial, elitist, and irrelevant to modern life, one that silently anticipates the viewer's encounter and then leads the individual by his or her epicurean inclinations.

I invited Laura Owens to be a resident artist at the Gardner Museum because of the collaging of form and space that occurs across its courtyard and through its corridors, an effect that parallels Owens's own process for making paintings. Looking through to images across framed spaces and at the carefully orchestrated contexts engendered by the Museum dares and enlivens the viewer's conception of the relationships between art, nature, and design, the source materials in Gardner's practice as an installation artist and in Owens's work, the recipients of her painterly address.

27

Gardner created her Museum as an intimate and subjective means to encounter undefinable knowledge. Through her eye the cultural education and pleasure that were virtually

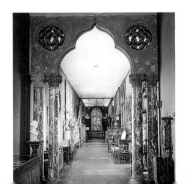

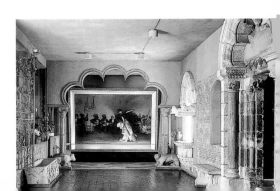

nonexistent in the United States at the turn of the nineteenth century were made available to the public of her day. As Susan Sontag clearly wrote of the sorry state of aesthetic engagement and stimulation in the 1960s, a socially, politically, and technologically revolutionary moment in American history set squarely between the time of Mrs. Gardner's enterprise and that of aspiring young artists such as Owens, "What is important now is to recover our senses."[2] Sontag's and Gardner's shared insight remains pertinent to the aesthetic needs of today's sensory-overloaded public. Fenway Court was laid out as

2 Susan Sontag, "Against Interpretation," in *Against Interpretation* (New York: Farrar, Straus, and Giroux, 1961), 13.

a sequence of slightly skewed cultural frames through which the visitor's values could be viewed from an exotic distance, through an oculus that perpetually renewed his or her view of the world. In opposition to the museum builders of her day and ours, Gardner recognized the need to return to ground zero of sensation, to take a step to-

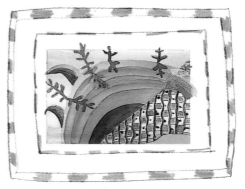

ward redirecting the visitor's primary sensory and sensual abilities. Fenway Court was Mrs. Gardner's opulent version of the Zen master's straw-thatched four-and-a-half-mat retreat from which, looking through the frame of different time periods, a new universe could be created.

In a similar spirit, it is to make paintings that operate as cultural lenses that Laura Owens picks up her paintbrush on a regular basis. Owens's project is skewed further than Gardner's by the knowledge that any framed image, whether it is of nature or culture, is a construction, not a representation of absolute truth. This loss of the idealistic Emersonian view of the mid-nineteenth century has leveled the playing field between nature and culture as the subjects of modern art and in human experience. In art, the modernist frame recognizes the boundary between nature and culture and defines the arena in which this

28

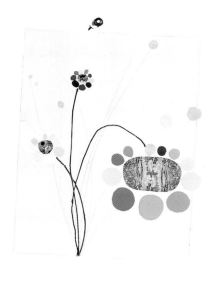

changing system of values is weighed out. Operating within the defined limits of painting, Owens is eliding the boundary between nature and culture, between image and illusion.

The Abstract Expressionists and many artists that came after them attempted to rectify the gap between nature and culture by doing away with the frame in order to break down the boundary between illusion and reality. Owens also removes the boundary of the frame, a decision she accentuates through the juxtaposition of natural and cultural images across the surface of many of her paintings. She conveys the incongruity of the position from which any painter must begin the task of making an image without having faith in what an image really is. She cancels out the easily assumed posture of cynicism by giving both nature and culture a false but real appearance in painting.

In 2000 Owens made a photographic collage that appears to be a view through a window of deciduous greenery over a calm and brilliant blue body of water, met on the horizon by an equally stunning expanse of clear sky. A fragment of a rock outcropping anchors the lower left corner of the composition. Onto the piece of paper on which the photographs are mounted, Owens has drawn in colored pencil two stacks of balls, one ascending, one descending in size, yellow, green, and brown, colors that underscore hues found within the image. As one

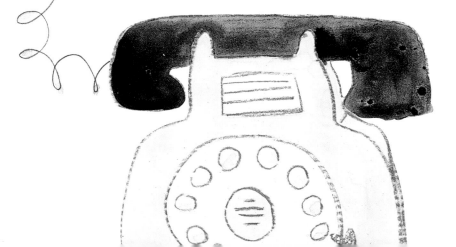

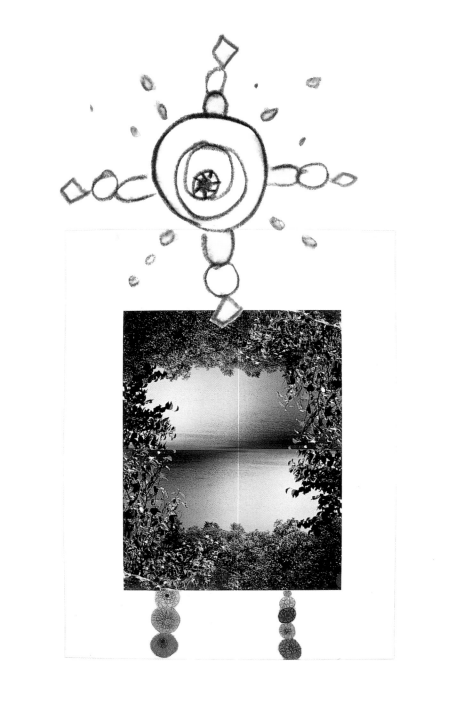

looks more closely through this window onto this sublime scene, it suddenly becomes apparent that this vision is the result of the duplication of a single image, one turned upside down above the other. The blissful view is an entirely contrived affair, the result of visual trickery of the first order. Despite the revelation of its view as keen artifice, the work continues to delight and soothe, even as a known felon of false representation.

Laura Owens has taken the elision of nature and culture on the field of the unreal one step further than her predecessors through her adaptation of the Japanese system of *shakkei*, in order to further resuscitate the picture plane. In Japanese culture, the frame has functioned in a different way, to bring life into art. The Japanese word *shakkei* literally means "borrowed scenery" or "borrowed landscape," in recognition of the distant views incorporated into garden settings as part of their design. In the original sense of the word it means a landscape captured alive, neither borrowed nor bought. In the way the Japanese conceive this distinction, if something is borrowed, it does not matter whether it is living or not, but when something is captured alive, it must invariably remain alive, just as it was before it was captured. For the Japanese garden designer, every element of the design is a living thing: water, distant mountains, trees, and stones. Owens's collage is a reverse of *shakkei*; her image is created by building a false frame from which the viewer sees a dead cultural object, or a replication of a mechanically produced image, the airless (meaning evacuated) space of illusion.

In this collage Owens directly addresses the principles for painting laid down by artists in the 1970s such as Frank Stella, whose flat abstractions, by banishing illusionism, emphasized the flowing of meaning across the surface of the picture plane. Stella's paintings presented the awkward truth that the shapes of things that appear on the fields of sensation and reason are nothing more than the simple negatives of the things themselves. This field of negatively defined culture was the prescribed field of operation about which painters had become so cynical in the 1980s and 1990s. Owens's representation of

mimesis through her Western *shakkei* creates a double negative, a positive place to carry on the task of making images.

In addition to her exhumation of the spaces of painting, Owens continues to build a vocabulary for her painting from art history. She sprays a little, draws a little, collages some, swashbuckles a little more, squeezes, squirts, dangles, drips, but consistently and unflaggingly paints like a demon, recounting the tales and techniques of such twentieth-century painters as Helen Frankenthaler, Pablo Picasso, Willem de Kooning, and Jules Olitski. Owens seems to have decided simply to paint right through the crisis that is supposed to be painting. Highly conscious of where she is beginning this improbable moment of painting, Owens appears to rattle off and dismiss the concerns that plague most of her peers: What should one paint? How should one paint? Can one paint? Owens just paints. She is accepting the modernist project of working through to the end, confirming her ability to act in history. She is happily resigned to making this the best moment for painting, one darn painting after another. It is evident that Owens has unconsciously but quite literally taken on the historical challenge to painters identified by Michael Fried in his well-known exchange with T. J. Clark about the nature of painting in the early 1980s. In redefining the task of the modernist painter, Fried concluded, "The essence of painting is not something irreducible. Rather, the task of the modernist painter is to discover those conventions which, at a given moment, alone are capable of establishing his work's identity as painting." [3]

Owens's work is a riff on art history; in fact, music offers the best parallel to her creation of new art with old forms. Her paintings find an equivalent in hip-hop remixes of top-ten hits. The familiar chorus returns after ten, twenty years, but the song has a completely different beat. In popular music the melody is the entry point or lure for true expression; we happily sing along while we indulge ourselves in what we experience as a familiar sentiment but is actually our private interpretation or engagement in a more fluid social expression. Owens's mark

32

3 Michael Fried, "How Modernism Works: A Response to T. J. Clark," *Critical Inquiry* (September 1982): 217–34, cited in *Pollock and After: The Critical Debate*, ed. Francis Frascina (New York: Harper and Row, 1985), 69.

making, palette, and imagery function in the same way. This fluidity of experience emerges from the way Owens exploits the cliché for painting. It neutralizes questions of whose touch? whose texture? whose gesture? The rote expressions she employs are everyone's art history. Through their appearance the viewer is relieved of the feeling that Owens is preaching her position and is freed to see that she is in fact addressing the questions that are on everyone's mind about art as well as those that are provoked by each individual painting.

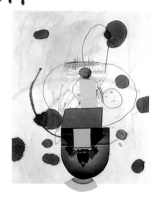

Cliché describes the referents of painting that have come to appear worn, haggard, and empty. Owens gathers all of these trite and overused expressions and ideas of painting that have become dull and puts them to work. She begins her paintings with a reference and follows where it leads her. As she has stated regarding this process, "I think that a lot of artists use a painting to point out a reference—a quote, an anecdote, or an idea—and that reference becomes more interesting than the work. I'd much rather have a reference generate a painting."[4]

Owens's painterly quotation and re-creation perfectly embody the type of global expression that Marshall McLuhan discussed in his book *From Cliché to Archetype* of 1970, the year she was born. McLuhan wrote of artists' discovery of the vulgar materials of their trade as exotic substances and their interest in revealing forms, an essentially modernist endeavor. But in the face of an exponentially complicated and information-confounded society, artists as narrators must take these materials and do what Owens has done; if the artist will "avoid realistic, pictorial description in favor of stylized and iconic blobs, [s]he can include more of the environmental complexity and motivation than pictorial realism permits."[5]

33

4 Owens, quoted in Morgan, "A Thousand Words," 130.

5 Marshall McLuhan, *From Cliché to Archetype* (New York: Viking Press, 1970), 203.

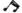

The primary material for this painter is painting itself. The discovery of art as the elemental resource for art was made in the later nineteenth century, when Isabella Gardner was making a museum out of art, not a house for art. Owens regards painting as the primary medium for making images. Its clichéd forms, like the cartoons and icons rightly identified by McLuhan, are charged with the accumulations of society's energy and perception. The distanced view, the moving of the viewer in and out of the space of illusion, enables her work to tap into what McLuhan called "corporate power" beyond private expression. Brian O'Doherty, in his well-known series of essays for *Artforum* in 1976 entitled "inside the white cube," addressed the role of the white-walled gallery space pictured in Owens's untitled painting of 1997 described above. He wrote of the power that operating in this modernist space can have, of its ability to affect the public and connect viewers with the language of art:

Expelled from the Eden of illusionism, kept out by the literal surface of the picture, the spectator becomes enmeshed in the troubled vectors that provisionally define the modernist sensibility. . . . If art has a cultural reference (apart from being "culture") surely it is the definition of our space and time. The flow of energy between concepts of space articulated through the artwork and the space we occupy is one of the basic and least understood forces in modernism. Modernist space redefines the observer's status, tinkers with his self-image. Modernism's conceptions of space, not its subject matter, may be what the public rightly conceives as threatening. . . . [6]

3 6

6 Brian O'Doherty, "inside the white cube," part 2, "The Eye and the Spectator," *Artforum* 15 (April 1976): 27.

So Owens, like Gardner, in her practice of making images through her creation of a swap meet of cultural reference, reinvests the forms of painting with new resonance. She reclaims them from their fate as retired hacks by placing them in a new space. Her gambit is the creation of an artificial landscape for painting akin to Gardner's construction of a

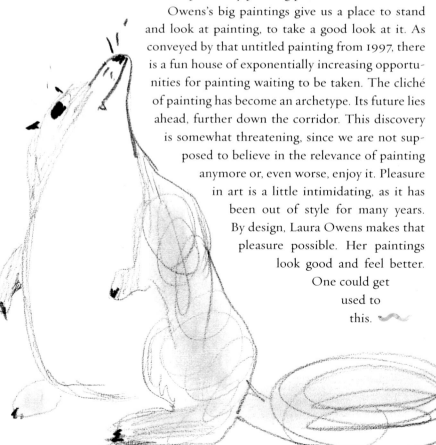

synthetic culture within her Museum. The resulting images remain aesthetically powerful but are readily identifiable as cultural fictions. For Owens, this method of collaging image sources results in the creation of works as an accumulation of painterly references that coalesce into a prototype for painting that is literally beyond reason. For Gardner, the result was a highly cultured version of Disney's Epcot Center, an accumulation of her international cultural expeditions gathered into one location. Although the experience offered by both artists cannot be encountered as authentic culture, their work has made it possible to engage with culture at all. This achievement is revolutionary in light of the condition of our senses in a world of overproduction and overinterpretation. Making it possible for the viewer to see and feel more is important work. It makes art and specifically painting possible.

Owens's big paintings give us a place to stand and look at painting, to take a good look at it. As conveyed by that untitled painting from 1997, there is a fun house of exponentially increasing opportunities for painting waiting to be taken. The cliché of painting has become an archetype. Its future lies ahead, further down the corridor. This discovery is somewhat threatening, since we are not supposed to believe in the relevance of painting anymore or, even worse, enjoy it. Pleasure in art is a little intimidating, as it has been out of style for many years. By design, Laura Owens makes that pleasure possible. Her paintings look good and feel better. One could get used to this.

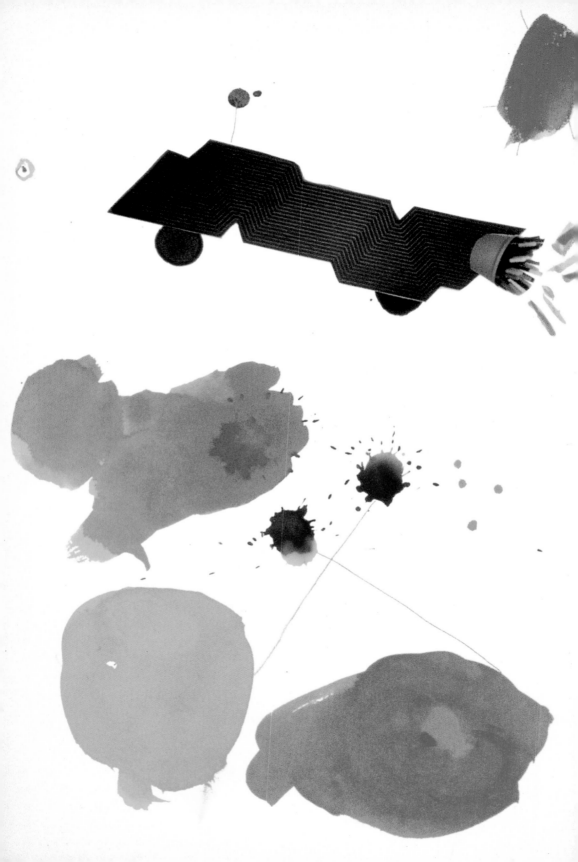

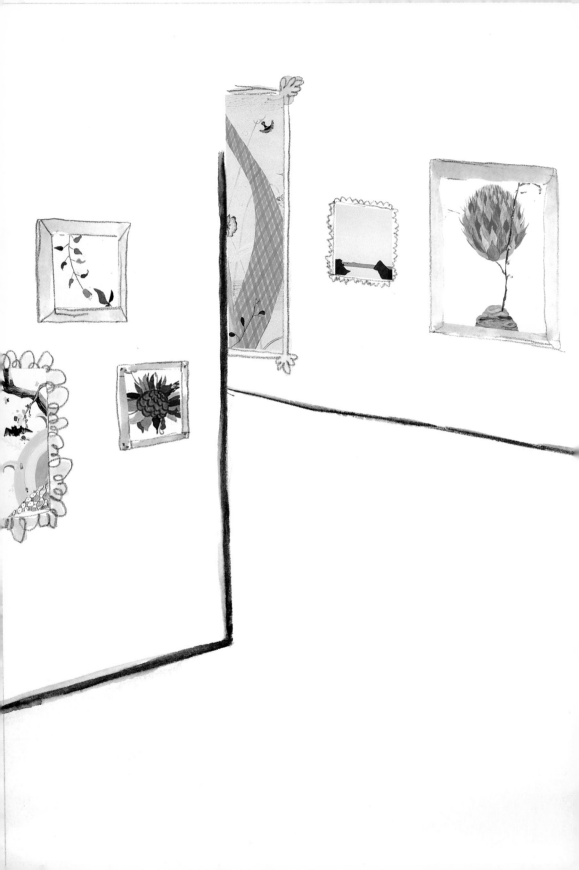

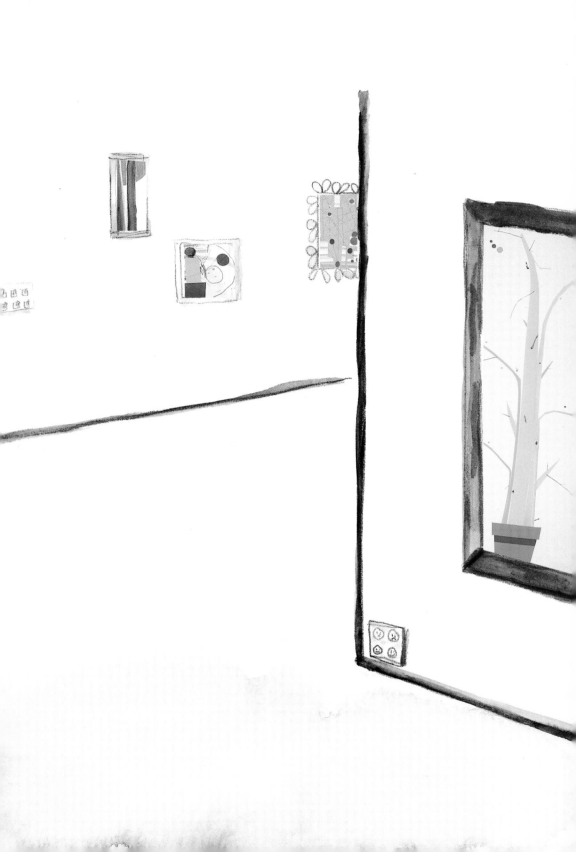

Journey
without a
Destination

RUSSELL
FERGUSON

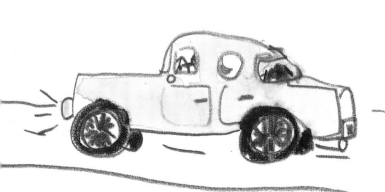

In THE 1960s, ambitious painters still sensed a historical inevitability to their work. They were advancing the discipline of painting. The task at hand was to consider their own role in a continuum that stretched far back into the past and would continue indefinitely into the future. Of course there were periods of turmoil, even revolution, but the tradition was expected to reemerge invigorated by such productive ferment. Artists competed to make the next breakthrough, taking the idea of the breakthrough for granted. In 1967, for example, Michael Fried, one of the most important critics of the period, could write of Kenneth Noland's "discovery" of the center of the canvas. It was discussed less as a compositional decision than as an inevitable development that had simply been awaiting the right artist, while its success had to be measured in terms of a leap of faith. "What Noland found when he discovered the center of the canvas was nothing less than how to make paintings in whose quality and significance he could believe, and this was not something he can be said to have had a choice about." [1]

45

1 Michael Fried, "Jules Olitski," in *Art and Objecthood* (Chicago: University of Chicago Press, 1998), 146.

For Fried, "discoveries" such as Noland's were significant primarily in terms of their ability to set new terms for painting itself. Each new move had to be convincing both to the artist making it and to other painters who would feel compelled to respond in their turn:

> We are speaking here of modernist painting as a special kind of cognitive enterprise, one whose success, in fact whose existence, depends on the discovery of conventions capable of eliciting conviction—or at least of dissolving certain kinds of doubts. (What at any moment those conventions are is in large measure a function of what they have been.) [2]

What Fried never doubted is that there would *be* conventions capable of eliciting conviction, even if their character was subject to debate and challenge. Increasingly, however, the value and sustainability of such an approach have been called into question. There is something profoundly arbitrary about painting now.

Robert Ryman's sincere and continuing attention to the white monochrome seems historical, more and more the "task of mourning" that Yve-Alain Bois described in 1986.[3] As early as 1981, Bois saw Ryman as guarding the "tomb" of modernism. "He holds an untenable position. He is perhaps the *last modernist painter*, in the sense that his work is the last to be able graciously to maintain its direction by means of modernist discourse." [4] As Bois indicates, modernist painting must have a "direction," even if it can be said (twenty years ago now) to have reached the point of exhaustion and even death. Increasingly, the advent of Minimalism in the late 1960s appears not just as a new style in an ongoing sequence but as a true

2 Ibid.

3 Yve-Alain Bois, "Painting: The Task of Mourning," in *Painting as Model* (Cambridge, Mass: MIT Press, 1990).

4 Bois, "Ryman's Tact," in *Painting as Model*, 225.

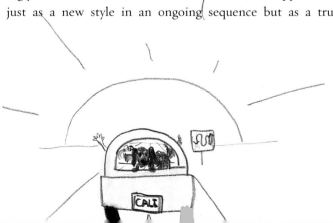

paradigm break, leading out of painting altogether rather than simply paving the way for the next generation of practitioners. Fried himself, one of the earliest and most perceptive critics of Minimalism, acknowledges that he could feel only "indifference and hostility" toward it.[5]

Painting continues, of course, but without the confidence in its own centrality that was once taken as given. "I pursue no objectives," Gerhard Richter could now say. "I have . . . no direction. I don't know what I want. I am inconsistent, non-committal, passive."[6] Neither old certitudes nor new conventions seem capable of commanding any more than conditional allegiances. No one style can or does claim more authority than any other.

But this situation does not relieve the painter of any burdens. The teleological imperative did at least offer the comfort of certainty and the shelter of history. If painting now is simply whatever anyone feels like doing, how does an ambitious painter chart a course through the apparently infinite possibilities? Laura Owens's paintings are the traces of such an effort. If she paints a biomorphic abstraction in 1999, and then the moon through the branches of a cherry tree the next year, can we describe the move as a breakthrough? We can, of course, but the rhetoric seems a little strained. While Owens is now an influential painter, the nature of influence itself has changed. Other painters certainly look closely at her work, but the sense of urgency and the polemic that surrounded, say, Philip Guston's return to representation is simply absent now. It is a given that you can paint as you like. For an individual painter, however, the questions of what and how to paint remain as problematic as ever. If Owens paints a white fog bank, it might on one level be a homage to Ryman, but fog is also something you can easily get lost in.

A small work on paper seems to me emblematic of Owens's project. It shows a ship under full sail. Each sail is represented

5 Fried, "An Introduction to My Art Criticism," in *Art and Objecthood*, 14.

6 Gerhard Richter, "Interview with Wolfgang Pehnt," in *The Daily Practice of Painting: Writings and Interviews 1962–1993* (Cambridge, Mass: MIT Press, 1995), 114.

47

by a different patch of fabric, each a potential painting in itself, each a potentially different direction for her to follow. Together, however, they will propel the ship forward. It is the kind of pirate ship one finds in children's stories. Pirate ships, remember, have no fixed course. They set sail out into the fog, but without any goal other than what they will find along the way.

Owens's exploration of painting, then, is a journey without a destination. This brief essay is, nevertheless, an attempt to indicate that despite the diminished currency of the teleological model, there is still a historical context against which to place her work. She meanders through a variety of territories, moving from the regularity of the grid out into skewed and forced perspectives, in and out of landscape and pure abstraction. Sometimes she will stain her canvases with the thinnest of washes. At other times paint will be applied in pellets so thick that the surface becomes a kind of relief. Passages of the subtlest paint handling coexist with childlike drawing. Recently she has been painting the figure, but in the same work she might also include extensive passages of pattern that again confuse the issues of representation and abstraction, significant form and decoration. Her self-portrait is a good example of this last tendency, as her own figure subsides into lovingly rendered depictions of rugs, blankets, and other fabrics. Owens presents herself literally embedded in a dazzling array of potential approaches to painting, only one of which is realist figuration. In another painting, two figures asleep in bed, in

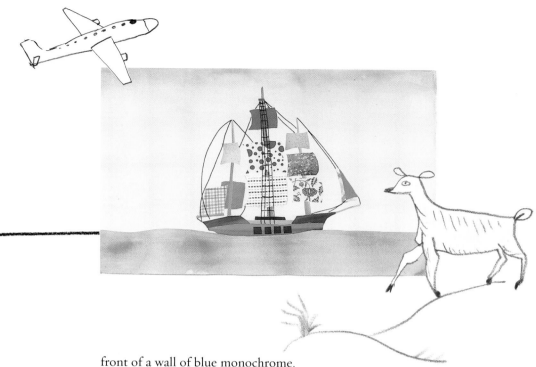

front of a wall of blue monochrome,
are almost completely enveloped in three different fabrics.

Owens's integration of both fabric patterns and patterned fabric into her work—sometimes painted, sometimes collaged—has been a consistent interest. In an earlier period, such a use of fabric, and of decorative patterns in general, would have been identified as markers of an explicitly feminist consciousness, a deliberate revalorization of modes of expression traditionally thought of as "women's work." In Owens's case, while such an interpretation would not be without some validity, the incorporation of these elements is also part of a more general inclusivity that regards any possible way of covering the surface of the canvas as equally available and equally legitimate.

Despite this eclecticism, Owens's paintings almost always achieve compositional coherence. Often, however, it can take a while for that coherence to become clear to the viewer. In large part, this is because the artist frequently embraces a deliberate awkwardness in her painting. The strategy of conscious "de-skilling" is one with deep roots in modern art. It can be found as early as Picasso's attempts to free himself of the

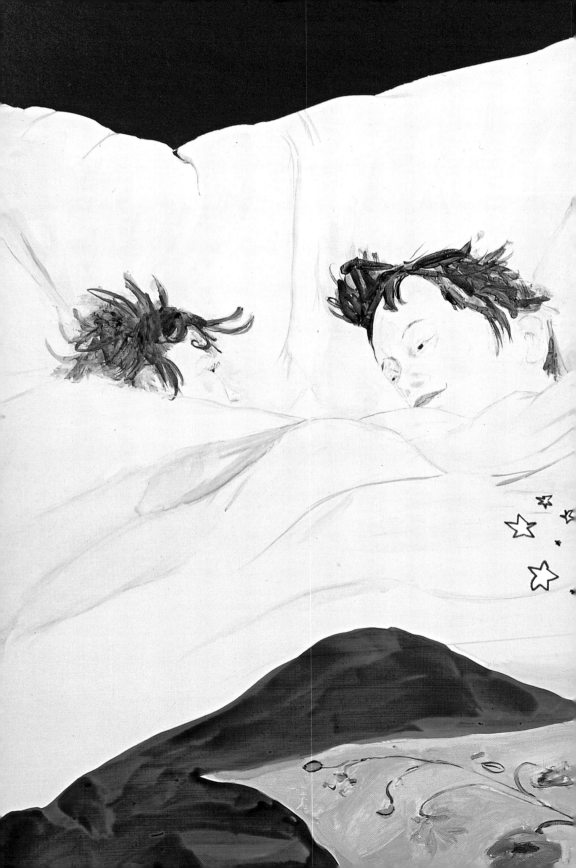

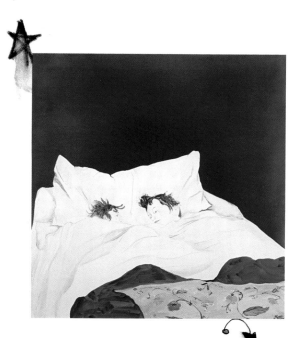

constraints of his own virtuosity, or even earlier, in Manet's use of the flat, unmodulated areas of paint that led contemporary critics to write that "he stoops to compete with house painters."[7] In 1948, Clement Greenberg wrote of Willem de Kooning that "The indeterminateness or ambiguity that characterizes some of de Kooning's pictures is caused, I believe, by his effort to suppress his facility."[8]

In this context, Owens's abrupt switches of approach from painting to painting, and even within a single painting—from ethereal abstraction to kitschy 1970s pastiche, from Japanese-inspired landscape to kindergarten doodles—stand in a long tradition of challenges that ambitious artists have issued to themselves. This is not "dumb" painting. Her work is exactly as dumb as it needs to be to keep Owens herself engaged.

With each new painting, then, Owens sets out to stretch her own limits. She has to give herself a new set of (more or less) convincing conventions for each new painting, without the solace of believing that any particular new set of conventions

5 1

7 Albert Wolff (1869), quoted in George Heard Hamilton, *Manet and His Critics* (New Haven: Yale University Press, 1954), 139.

8 Clement Greenberg, "Review of an Exhibition of Willem de Kooning," in *The Collected Essays and Criticism*, vol. 2, *Arrogant Purpose, 1945–1949* (Chicago: University of Chicago Press, 1986), 229.

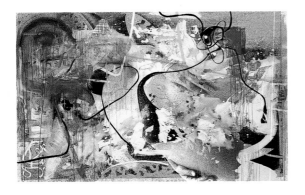

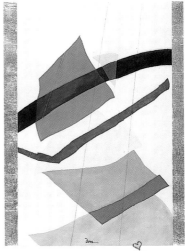

THIS PAGE:
left, Albert Oehlen
La Veneno, 1998
Oil on canvas, 63 x 95 inches
courtesy Galerie Max Hetzler, Berlin.

right, Arthur Dove
Rain or Snow, 1943
Oil and wax emulsion on canvas, 35 x 25 inches
The Phillips Collection, Washington, D.C.

THAT PAGE:
left, Mary Heilman
Bab Boujelloud, 1996
Oil on canvas, 58 x 39 inches
courtesy Pat Hearn Gallery, New York.

right, Mary Heilman
Lola, 1996
Oil on canvas, 78 x 58 inches
courtesy Pat Hearn Gallery, New York.

9 Laura Owens, quoted
in Susan Morgan,
"A Thousand Words:
Laura Owens Talks
about Her New Work,"
Artforum, summer
1999, 131.

will necessarily convince anyone else, or even herself, when it is time to begin the next painting. "That motivates me," she has said, "this idea of trying to start over every time. That's what keeps painting interesting (and maybe a little bit scary) for me."[9] The process of discovery has to be sustenance enough in itself, without the promise of arrival.

Identifying any kind of lineage for a painter who deliberately sets out to reinvent her own painting with each new canvas might seem a fruitless task. And the range of Owens's explorations certainly offers a potential multiplicity of comparisons. A few figures, however, seem to me of particular significance. Arthur Dove's willingness to incorporate collage alongside painting; his rejection of contemporary painting conventions; his frequent changes of styles; and his consistent engagement with landscape—all these features make him a precursor. Consider *Rain or Snow* (1943), in which paint and metallic leaf combine in a composition that is simultaneously purely abstract and directly evocative of the natural world. In

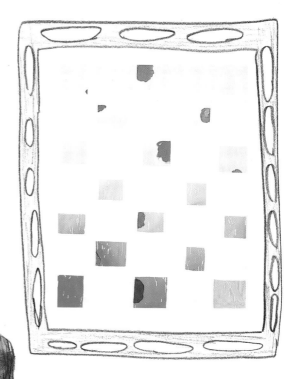

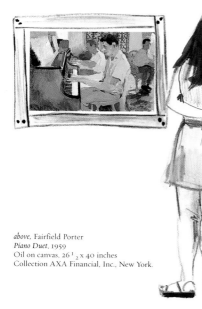

Fairfield Porter's work we can also see the productive tension between representation and abstraction, and a few apparently clunky moments that serve a larger compositional purpose. Neil Jenney's paintings of 1969 and 1970 present a clear demonstration of the power of "bad" painting to get to previously unreachable places. In *Birds and Jets* (1969) both birds and jets emerge drippily from a miasma of painterly white sky. The birds in particular find a direct echo in some of Owens's modeling-paste gulls.

Among artists who are somewhat more her contemporaries, Owens has expressed her admiration for the work of Mary Heilman, whose paintings certainly have an insouciant

above, Fairfield Porter
Piano Duet, 1959
Oil on canvas, 26 $\frac{1}{2}$ x 40 inches
Collection AXA Financial, Inc., New York.

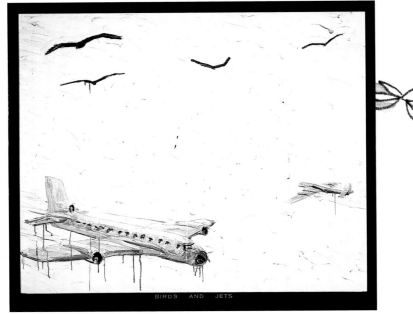

Neil Jenney
Birds and Jets, 1969
Acrylic on canvas with painted wood frame, 61 x 71 3/4 inches
Private collection, courtesy Thomas Ammann Fine Art, Zurich

quality evident in her own work. The long series of challenges to painting (and to art in general) thrown down by Martin Kippenberger and artists associated with him, notably Albert Oehlen, have also clearly been important. These artists' embrace of the idea of failure as a productive element for their own work resonates with Owens's willingness to push her paintings to the point of collapse. In terms of composition in particular, Diedrich Diedrichsen's remarks about Oehlen's work might also apply to Owens's: "It's not a question of the number of elements, but of the distinctions among them—these being as great as possible while still allowing interferences and relationships to develop." [10]

In the end, the very eclecticism of such lists as the above indicate the degree to which Owens's work remains resistant to pigeonholing. "Ultimately," she has said, "you really want to make the painting that you want to be with." [11] That statement indicates the scope of her ambition as well as its resolutely personal nature. Any painting she makes has to satisfy

10 Diedrich Diedrichsen, "Triumphs, Setbacks, Rear Exits and Cease Fires: Some Aesthetic Issues Concerning Albert Oehlen, and Some Architectural and Musical Comparisons," in *Oehlen Williams 95* (Columbus: Wexner Center, 1995), 103.

11 Owens, quoted in Morgan, "A Thousand Words," 131.

only her. In some ways this is not so far from Kenneth Noland's struggle to make paintings "in whose quality and significance he could believe," and yet it is also very different. Noland still painted in the context of an unchallenged primacy of painting. If he could convince others of his discoveries, he could feel confident in their importance. While facing as many challenges before each fresh canvas, Owens has to proceed without belief in historical inevitability. If we like the results, that's good—but Owens herself will already be on to the next challenge, starting over every time.

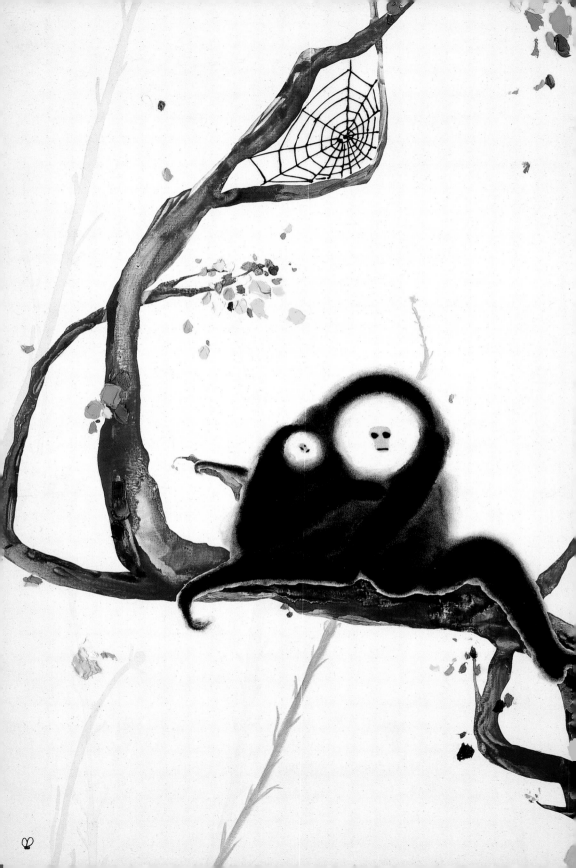

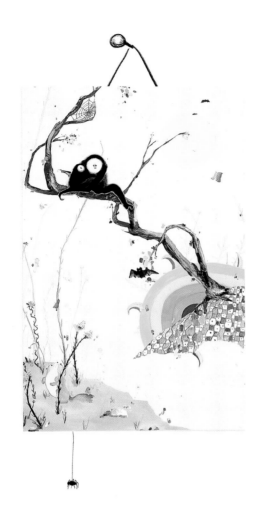
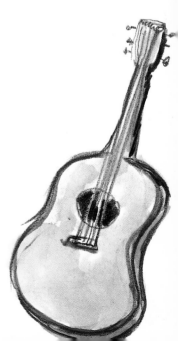

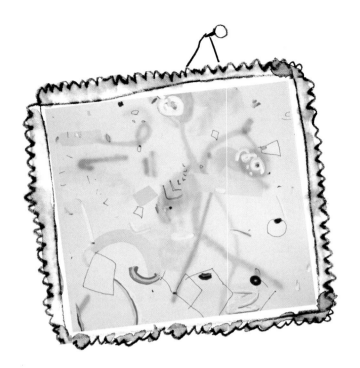

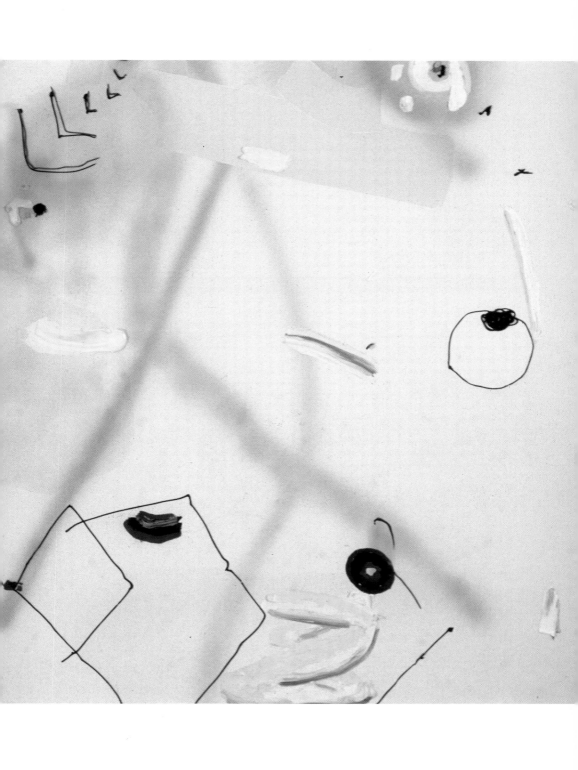

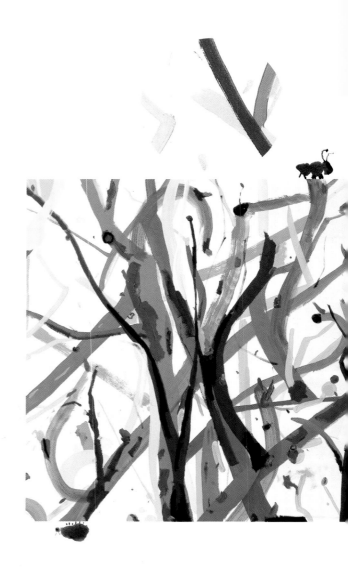

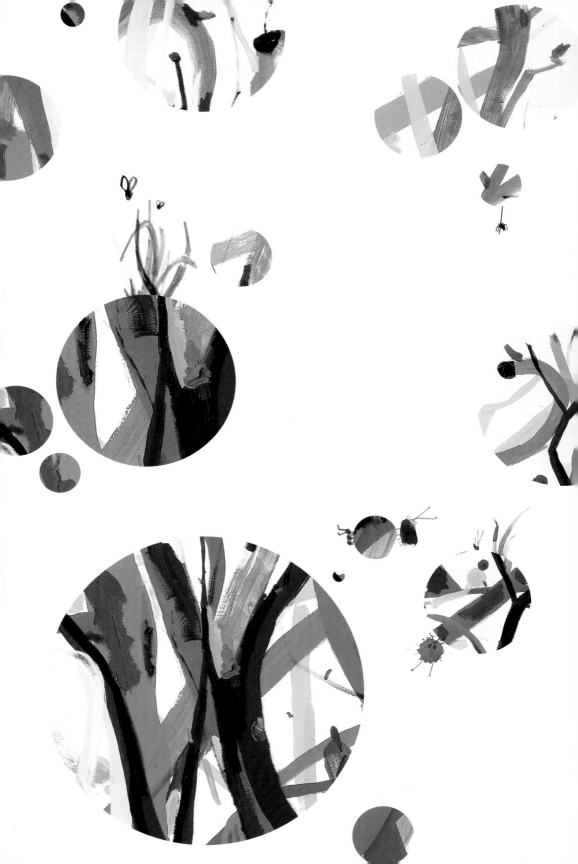

Laura Owens is represented by a very nice man named

LIST OF ARTWORKS

Gavin Brown who has a gallery in New York City.

ADDITIONAL DRAWINGS
© LAURA OWENS 2001

CREDITS:

courtesy Gavin Brown's
enterprise, New York: pp. 8, 9,
14–15, 22–23, 28, 29, 55.

courtesy Sadie Coles HQ,
London: pp. 6–7, 11, 12–13,
16–17, 18, 20, 26–27, 30, 34–35,
43, 58–59.

courtesy Gisela Capitain,
Cologne: pp. 9, 11, 33, 38,
42–43, 60–61.

courtesy Studio Guenzani,
Milan: pp. 10, 49, 50–51.

courtesy ACME.,
Los Angeles:
pp. 9, 22, 56–57.

Laura Owens

very much appreciates all the

help and support from Edgar Bryan,

Gail Swanlund, Jennifer Gross,

Russell Ferguson, Kirsty Bell,

Gavin Brown, Sadie Coles,

Claudio Guenzani, Bob Gunderman,

Randy Sommer, Gisela Capitain,

Bettina Hubby, Corinna Durland,

Tiffany York, Chris Aldrich,

Pieranna Cavalchini, Anne Hawley,

Faris McReynolds, Portia Hein,

Jon Furmanski, Kippy Stroud,

Candy Depew, Everyone working at

the Gardner who made my stay

so enjoyable, Scott Reeder, Ruth Root,

Michael Webster, Monique Prieto,

Sara Whipple, Elizabeth Hin Eckley,

Gary Altrichter, Chuck Thompson,

Dick Hendrickson, Lincoln Owens,

Lisa Owens, Carol Hendrickson

and

Lucy.

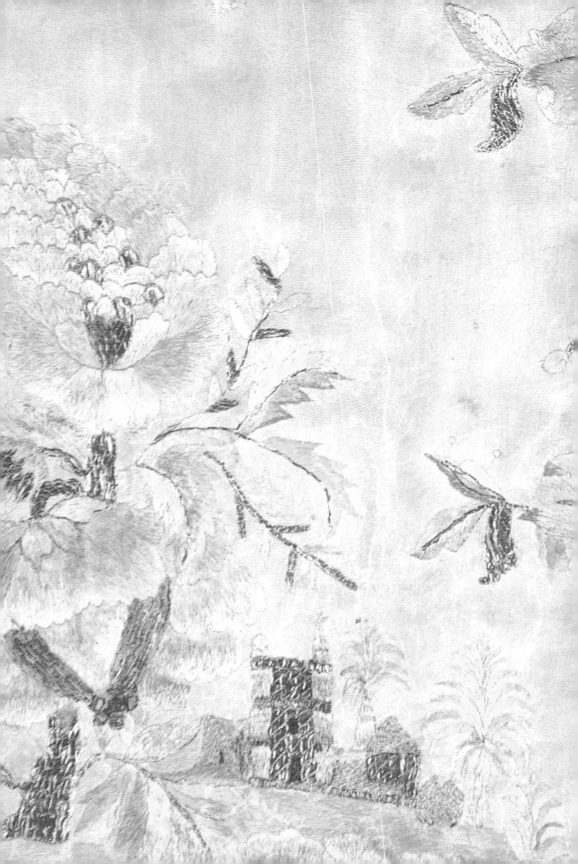